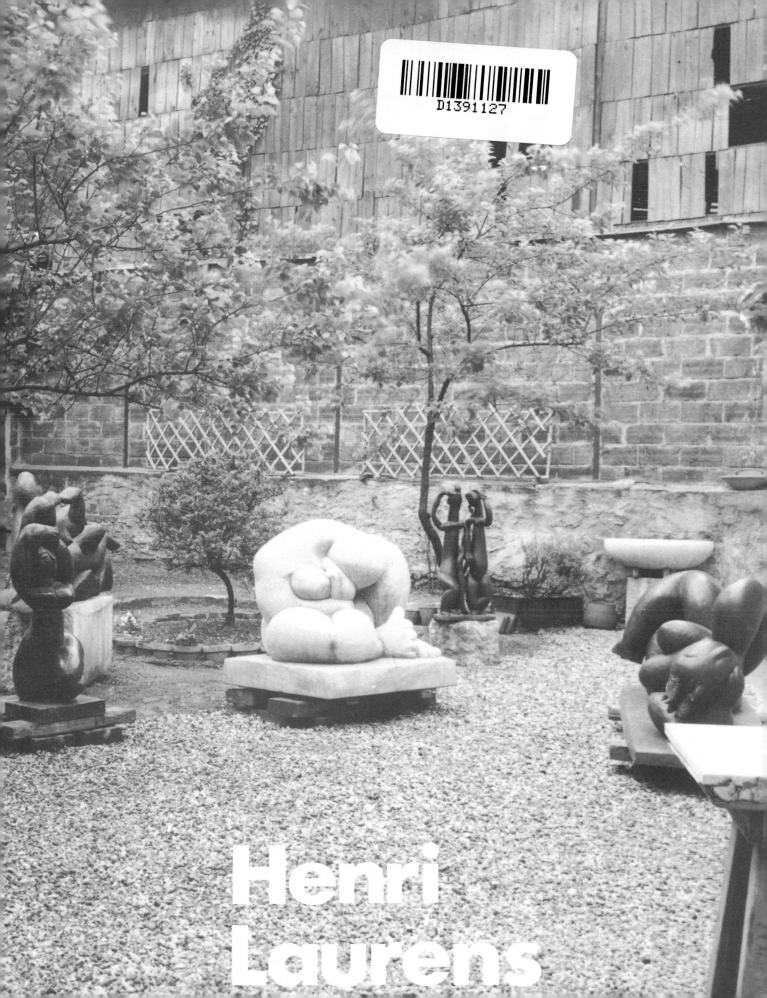

Henri
Laurens

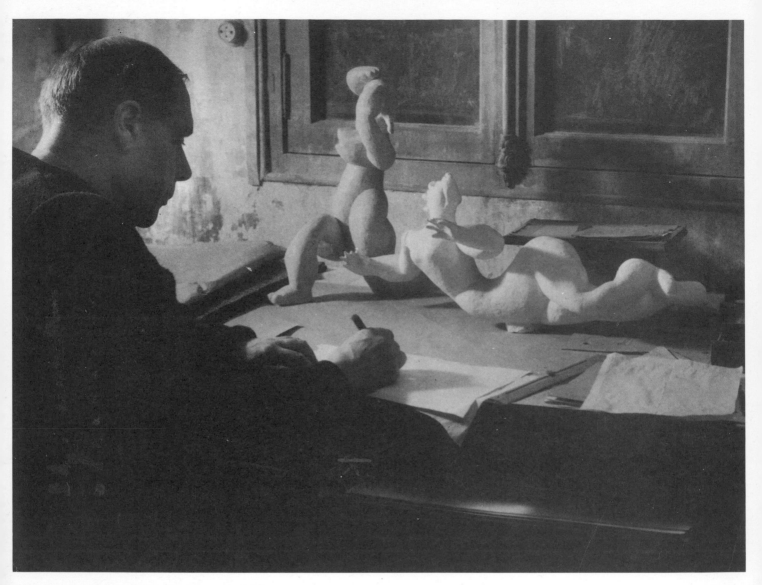

Henri Laurens photographed by Brassai in 1946

Henri Laurens

bronzes

collages

drawings

prints

Arts Council
OF GREAT BRITAIN

Preface

Joanna Drew
Director of Art

In 1971 the Arts Council presented a Laurens exhibition at the Hayward Gallery. We are now delighted to be able to offer a newly formed exhibition in four major galleries outside London.

A travelling exhibition of Laurens sculpture must inevitably be limited in its scope. The fragility of terracottas, constructions and polychrome stone sculptures makes proper representation of his earlier work impossible. Happily, his later work was largely in bronze and constitutes a remarkable contribution to the history of sculpture in this century. The exhibition concentrates therefore on the later bronzes and drawings with the addition of some Cubist bronzes and a small group of his Cubist collages and graphic work.

As before, we are deeply indebted to the artist's son and his wife, Monsieur and Madame Claude Laurens, whose enthusiasm and patient help have been invaluable. We have also been aided most generously by Monsieur Maurice Jardot and the Galerie Louise Leiris. To them we extend our warmest thanks. We should also like to thank those owners who have kindly lent much-loved works from their collections.

Introduction
Michael Harrison

"Picasso used to say to me, about Cubism: 'Why did we abandon it? It was so magnificent'.

"At the time of Cubism, we all thought along the same lines. But we couldn't go on making papiers collés all our lives. We gave all we could in that common endeavour. After that each of us had to go his own way."[1]

49 Femme à la mantille *1917*

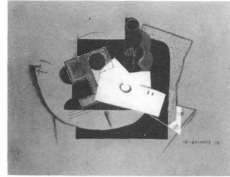

50 Nature morte *1918*

Unlike Picasso and Braque, Henri Laurens produced his first mature work as a Cubist. He met Braque, who became a life-long friend, only in 1911 when Cubism was no longer exclusively the preserve of its inventors. Whatever work Laurens had made before was destroyed or discarded and he now came to create some of the most remarkable constructions, *papiers collés* (literally 'stuck papers') and carvings of the Cubist era.

To a young artist an encounter with the utterly contrasting yet equally compelling personalities of Braque and Picasso - the one three years older than him, the other four - must have been irresistible and it is not hard to understand his attraction to Cubism. The greater difficulty, if difficulty there is, in comprehending his career is in coming to terms with his eventual abandonment of Cubism and his adoption of what would perhaps seem a retrogressive figurative style.

Cubism was, above all, a movement which had freed artists from the constraints of the Renaissance tradition, but, in establishing its own forms, it could easily have devised its own straitjacket. For some indeed it did and the vitality of new language dwindled into accomplished decoration and cliché, but for others the paths beyond were various. The move towards abstraction was possibly the most logical route -

certainly for those believing in the 'progress' of art - though one taken by rather few French artists. Instead, Laurens, like Picasso and Braque, sought some reconciliation with the tradition of art which they had apparently done so much to overturn. Reconciliation could suggest some kind of climb down and may be the wrong word. Perhaps it was rather a question of Picasso and Braque being first and foremost painters rather than Cubists, and Laurens a sculptor. After so effective and complete a revolution was it not time to assess its implications for painting and sculpture as such? It was also time for these artists, now in their mid or late thirties to equate the formal means now at their disposal with the type of art which they personally wanted to create.

Subject-matter played a large part. Still-life had been the main subject of Cubism, providing as it does the most flexible and apparently most neutral opportunity of contriving compositions. For Braque it was more than that - a still-life transcended the state of being an impersonal collection of objects - and he continued to explore the *rapport* which he found amongst the objects and between them and himself. But the human being had always been more important to Picasso: *"Everything appears to us in the guise of a 'figure'. Even in metaphysics ideas are expressed by means of symbolic figures."* (Picasso, Zervos, 1935)

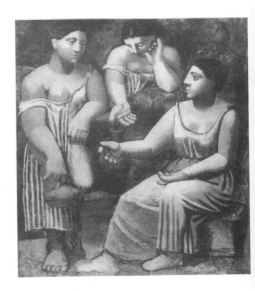

Picasso Three women at the fountain 1921, Museum of Modern Art, New York

And of course the history of western sculpture is almost completely confined to the treatment of the human figure, and predominantly the female. Given such limits of subject its tradition was narrower than that of painting and the degeneration of academic sculpture, uneasily combining a titillating and obviously contemporary realism with the respectable trappings of classical timelessness, was all too evident. Rodin and Degas offered dynamic alternatives in their explorations of movement but, for a sculptor like Laurens, seeking an art of calm, stability and harmony, their example at this time would have had little relevance.

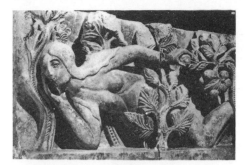

Gislebertus Eve at Autun

possible when you compare her hair to that of the Laurens bas-relief **Femme couchée** (cat. 3). Yet, despite its contortion, the Gislebertus figure is remarkable for its gentleness and introspection, qualities it shares with Laurens's **Tête de femme** (cat. 6). Here the beauty of the head is in its tilted poise, in the flowing lines of the hair against severely cut facial features, and in its quality of metaphor - the hair is a leaf-like husk parting to reveal its barely awakening fruit.

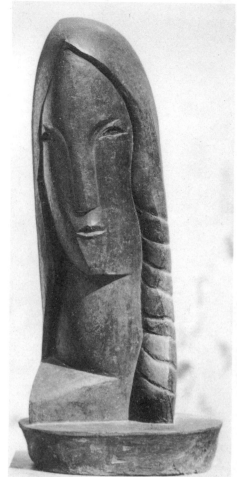

6 Tête de femme 1925

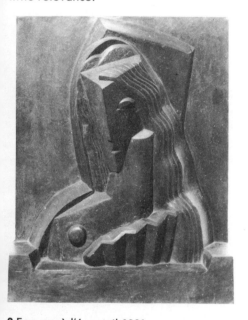

2 Femme à l'éventail 1921

As a Cubist, Laurens, like his contemporaries, had looked outside the tradition of imitative sculpture to the newly discovered Negro art and, back beyond the Renaissance in Europe, to Romanesque sculpture. Neither of these arts relied upon imitation or idealisation of the real. They taught the Cubists - or at least confirmed them in their intention - to discard conventional notions of beauty and to recreate the human body anew as sculptural form. The African influence is well enough known and has possibly overshadowed the Romanesque.[2] It is certainly worth bearing in mind a figure such as that of Eve sculpted by Gislebertus at Autun when looking at the four reclining figures (cat. 1, 3, 5, 8) in the early part of this exhibition. The sculpture of Eve complies with an almost geometric format: her torso is twisted into frontality. A fairly direct link seems

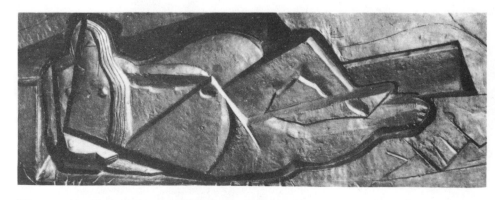

3 Femme couchée 1922

Eight years separate **Femme à l'evéntail**
(cat. 1) and **Femme couchée à la draperie**
(cat. 8). In the earlier sculpture the upper
part of the body, angular and alert, is
raised on one elbow almost into the
vertical with facetted breasts jutting from
flat surfaces. The figure then turns into
the horizontal but massive rounded
haunches rise as a mountainous
landscape with drapery flowing wave-like
beneath. Both sculptures are essentially
frontal and in effect reliefs. **Femme
couchée à la draperie** is a linear
composition fleshed out into rounded
form. The crucial change is uneasily
taking place in Laurens's work. Laurens is
attempting to make of the figure a single
coherent unit. But here he has met
problems for the human figure has
awkward elements which conspire
against such sculptural conciseness. He
has therefore shrunken protruding feet,
head and breasts and suppressed the
hands entirely so that a continuous flow
of forms might be achieved. Even the
arms extend on into billowing drapery.

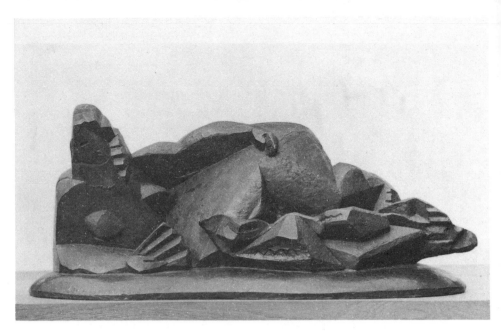

1 Femme à l'éventail *1919*

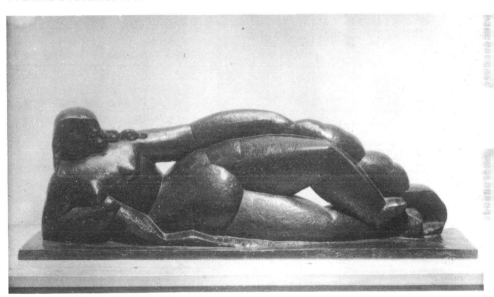

8 Femme couchée à la draperie *1927*

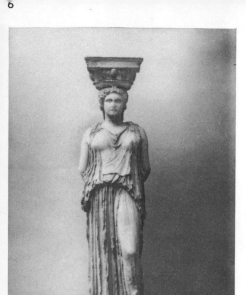

Cariatid from the Erechtheum, Athens
Trustees of the British Museum

"In the days of Cubism we were profoundly individualistic. We were only interested in the object as such. We had no other problem than the one set by a simple concern with sensation, a sensation of volume, and a concern with that of volume.

"Now others of later generations, will profit from our experiments and integrate them into a monumental art. This aim, which they seem to be setting themselves, is a great aim. But if they had no other, this work would become wholly decorative. And that would be a pity for gifted sculptors, those with something to say.

"Still, the sculpture which is now tending towards the monumental will abandon our old bias for absolute individualism in favour of another bias - towards the application of sculpture to architecture, or better still to a concord between them."

For Laurens the 1920s was a time of problem solving. During his Cubist period he had been making constructions and carving directly into stone. Construction, through the addition of parts, is the most free method of making sculpture, and of making sculpture of open form. Carving is the opposite, removing rather than adding, working inwards towards a compact form. In the '20s Laurens had moved increasingly to modelling in clay, casting in plaster and then either carving in stone, using the plaster as a maquette, or casting in bronze. Even so costs frequently demanded that modelled clay should become *terracotta* rather than bronze. It was as though he saw carving as the true path but modelling allowed a more economic means and a more tentative and experimental approach.

Bronze was also the obvious medium for large-scale work and Laurens's apprenticeship in decorative sculpture had left him with a strong feeling for the part which sculpture might play in architecture. The group involvement of Cubism and its exciting climate of innovation provided sufficient moral sustenance but the First World War had

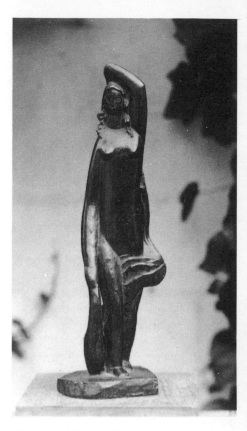

9 Femme debout à la draperie au bras levé *1928*

dispersed the group, and Laurens, some years later, realised that he could take Cubism as such no further. There was undoubtedly a conflict to be resolved between the Cubist assertion of sculpture as an independent object and Laurens's ambitions for its application.

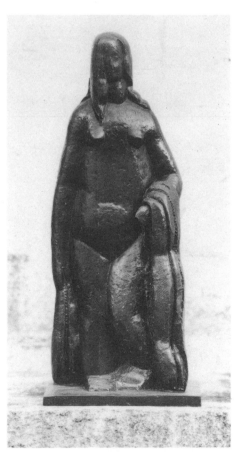

10 Femme debout à la draperie *1928*

Two standing figures of 1928 (cat. 10, 11) are cariatids. Indeed **Femme debout à la draperie** is the small version of a sculpture 2¼ metres in height, the first of the great monumental bronzes. They are cariatids but they were never to carry the burden of an architrave. Laurens's figures are modelled rather than carved and their whole being is devoted to supporting themselves. **Femme à la draperie** rises against its own weight. Here we can see the marrying of Cubism and antiquity. A look back to the still-life reliefs shows how Laurens, like other Cubists, had played upon the symmetry of a fruitbowl or a guitar. Here the vertical axis of Cubist composition is merely a seam dividing the figure into unequal halves. To one side each element - hair, arm, drapery and leg - descends straight and vertical; the other side is relaxed - arm and leg are bent, hair and drapery ripple down. Laurens has undressed his figure so that clothing cannot mask the gap which would normally occur between bent and straight legs. Instead her right leg is drastically shortened so as to join the left. There is the implication of compression beneath the body's weight and, at the same time, of the figure rising tree-like from the earth.

4 Compotier et grappes de raisins 1922

Femme debout à la draperie au bras levé (cat. 9) is light-hearted - almost coquettish. The left arm is raised to accommodate the head into the overall form of the figure and allows a drapery to drop down the back. The cloth substitutes for the raised arm down the side of the body, and then snakes through the legs and up to the other amusingly elongated arm. The solution of the problem has in effect become the subject of the sculpture.

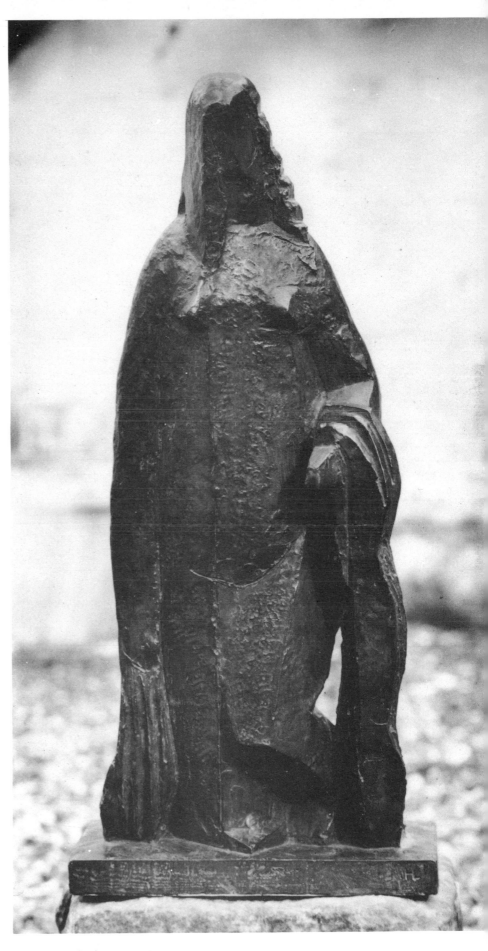

11 Femme à la draperie 1928

The sculpture actually called **Cariatide** (cat. 13) would seem to be the final answer to the formal problem of the human figure as a continuous and compact form. It was a common quest. Brancusi's **Kiss** brought together two half-length figures in a single block but he abandoned the whole figure for the treatment of single elements. Picasso, in 1907, Derain and Laurens's friend Modigliani had all approached the task. In **Cariatide** arms raised and wrapped around the head continue the form of the torso. At the back the hair is like a massive clenched fist and the whole figure is charged with that tension, relieved by one flowing, voluptuous curve, which exists only in line where the drawn up leg meets the upper body.

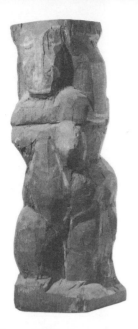

Picasso Figure 1907
Réunion des musées nationaux, France

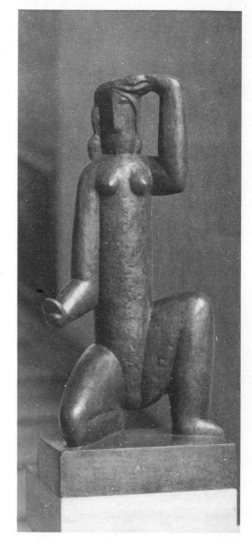

12 Grande femme au miroir *1929*

Some months earlier Laurens had begun work on a figure whose origins in African wooden sculpture are clear (cat. 12). We might also compare its articulation to a *papier collé* of 1917 (cat. 47) and thence to the constructions of that time, for here there is the first hint of Laurens going back to exploit the sculptural possibilities which Cubist construction had opened up. Component parts can be separated one from the other and space allowed in as an active participant. Immediately sculpture becomes more emphatically three-dimensional.[3]

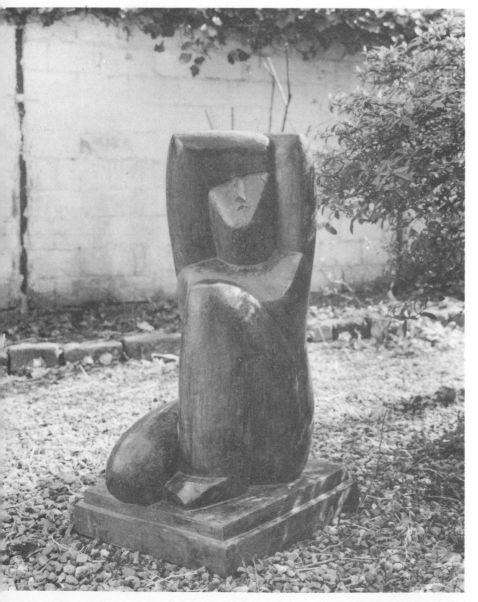

13 Cariatide *1930*

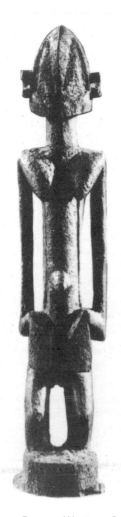

Ancestor figure, Dogon, Western Sudan
Margaret Plass Collection, Philadelphia

The **Baigneuse** (cat. 14) is a sculpture by someone far more relaxed and freely inventive than the Laurens of the '20s. Through its truncations, Laurens can allow the breasts to jut out and swell, equally assertive as the head and arms. And leaning back on one arm, the centre of gravity of the torso is shifted away from its mass.

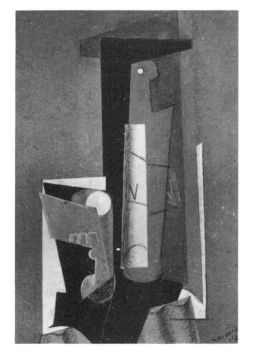

47 Bouteille et verre *1917*

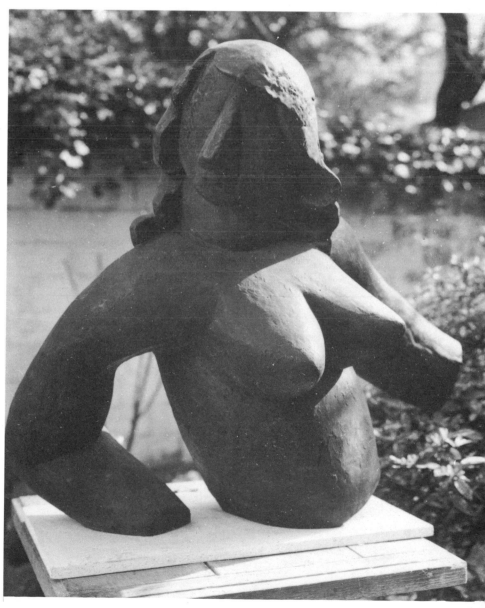

14 Baigneuse (fragment) *1931*

In **Femme à l'oiseau** (cat. 15) Laurens has composed a figure in an almost swastika-like pattern. As we face it the body's trunk curves diagonally up from bottom left to top right and, with the strong verticals and horizontals of the limbs, is freed of its function as a dominant core to the sculpture. Each element, even the triangular gaps, is as important as any other but there is no fear of the human figure becoming merely a uniform geometric device. Her upper half is sharp and angular (remember the Cubist reclining figures) while the big rounded belly and legs set her firmly on the ground. Despite it being a woman's body there is the feel of a young child, agile and discovering itself though not yet upright and walking. Even seated there is the chance of the figure toppling: in profile we find it leaning forward towards us, but steadied by an out-thrust leg which echoes the raised arm.

With this sculpture, Laurens had achieved a finely poised, though thoroughly robust and fertile balance between anatomical and geometric, or sculptural, structure — or, more broadly, between the structure of nature and the structure of art. For, while sculpture exists in three-dimensions as does the human figure, their laws are quite different. An adult person, for instance, can stand on two feet through an intelligent, if unconscious, control of muscle. A sculpted figure has no such powers and to remain erect must depend on a counterbalancing base or become a tripod instead of a biped.

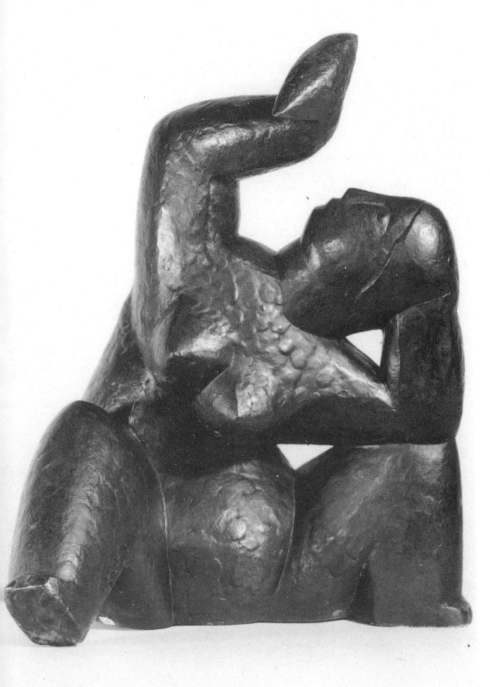

5 Femme à l'oiseau *1932*

"When I begin a sculpture, I only have a vague idea of what I want to do. For instance I have the idea of a woman or of something related to the sea.

"Before being a representation of whatever it may be, my sculpture is a plastic act and, more precisely, a series of plastic events, products of my imagination, answers to the demands of the making. That, in short, is all my work amounts to.

"I provide a title right at the end."

After the twenties the figure rarely appears standing in Laurens's work. It is normally seated or reclining and there is then no conflict between sculptural and anatomical form. By bringing space into his sculpture Laurens realised that forms and forces could be so balanced as to allow poses suggesting movement, and yet achieve stability.

There is an obvious change in Laurens's work at this time for instead of giving sculptures titles which merely describe their pose — 'crouching woman', 'woman with drapery' — he began to give them more metaphoric names. The titles came only when the sculpture was completed but it indicates that Laurens now felt his work capable of expression beyond the immediate problem of form.

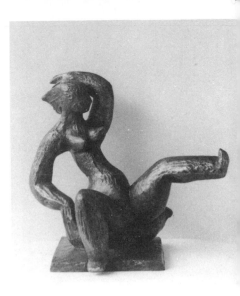

18 La vague *1932*

La vague (cat. 18) joyfully celebrates the new freedom in Laurens's sculpture. The right leg is thrust out to steady the figure but the left kicks into the air and, visually, its balancing force is the space between the right arm and the body rather than any actual counter-weight.

In **Architecture** (cat. 16) the figure appears as matter wholly subject to the space around it, frail, barely modelled into rough streamers.

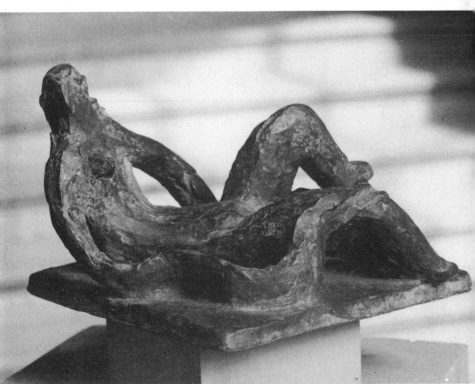

16 Architecture *1932*

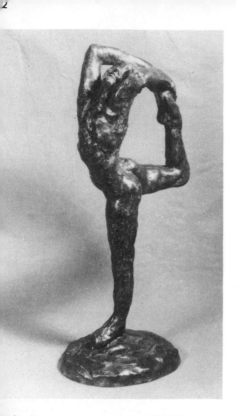

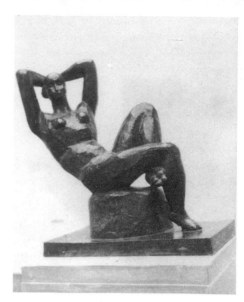

Matisse Large seated nude *1925*

We could perhaps, at this stage, pause to consider the effect which other artists' work might have had on Laurens. Certainly it would seem likely that he would now find more sympathy for Rodin's later work. More immediately, Matisse's sculpture offered a valuable precedent in posing the figure in a barely held balance and indeed in moving from the representation of the human form to its sculptural recreation. But the new climate in which Laurens lived was that of Surrealism. The violent rejection of rationality by Surrealist artists and poets was quite foreign to Laurens's temperament but their interest in the unconscious and sub-conscious, and, not least, in the concept of metamorphosis, was not without relevance. We might for instance bear in mind the biomorphic beings which Miró conjured up in his paintings. Not surprisingly, however, it is with Picasso that we discover the strongest link, and, probably, influence. In 1931-2, at his new home, the Château de Boisgeloup, Picasso modelled a number of sculptures in which he reconstituted the female figure with little deference to anatomical reality — breasts can spring from arms just as easily as from a torso.

odin Dance movement A *c1910-11*
eeds City Art Galleries

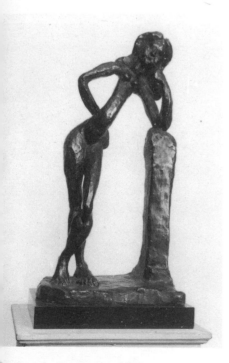

Matisse La Serpentine *1909*

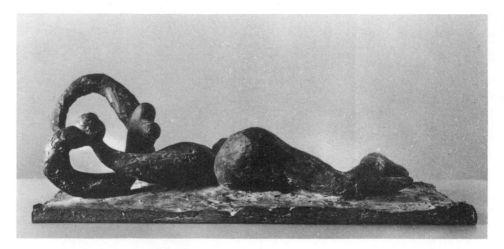

Picasso Reclining Woman *1932*
Réunion des musées nationaux, France

Laurens's **Le torse** (cat. 23) is extreme in its handling of the human figure. The triangular head is divided vertically Cubist-fashion. A bolster-like form is bent, combining arms and breasts — a single curve on the outside, sharply angled on the inside. An arm doubles as a leg in a single limb.

Rosa (cat. 22) is a close relation to Picasso's **Reclining woman** of 1932 but the comparison makes Picasso's figure appear unresolved and unparticular in expression. The upper body of **Rosa** thrusts upwards, stretching the waist as a slender stalk to impossible thinness. The arms do not meet to make a circle but form protective lobster-like claws around the head. One leg rises towards the breasts and head, as Werner Hofmann convincingly argues, in some kind of self-fertilising posture.

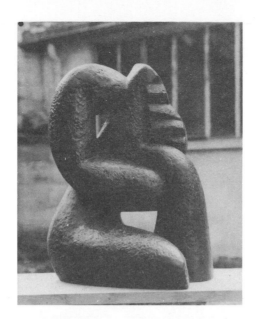

23 Le torse *1935*

"I look for stability even when representing movement. Movement doesn't disturb the impression of calm m sculpture is meant to give . . . Harmony, the laws of plastic form that govern them their system of volumes generating one another, the fact that the voids count no less than the masses — all this tends to lend them stability.

"Besides, I haven't got a violent nature."

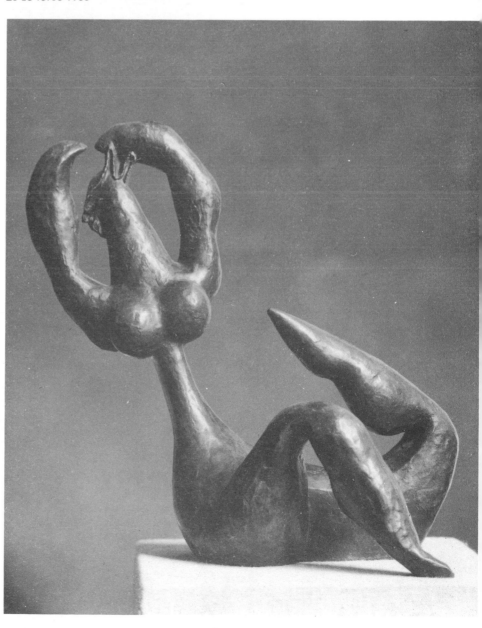

22 Rosa *1935*

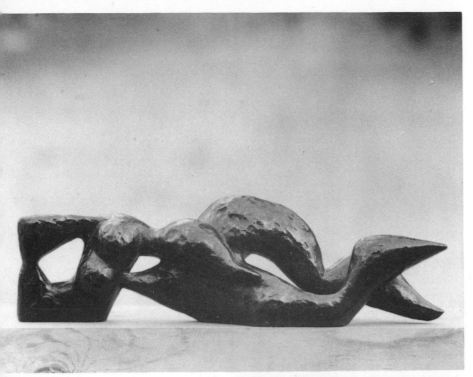

1 Eventide *1935*

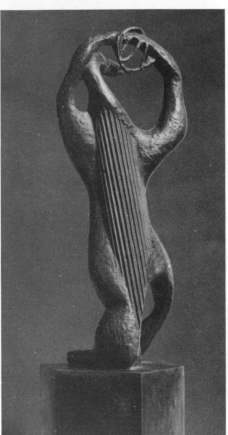

24 L'Amphion (petit) *1937*

But let us return to the question of titles. The names which Laurens now began to give some of his sculptures evoking music, the sea, a time of year or day are not original in themselves. We can think of Michelangelo's **Dawn** and **Dusk**, **Night** and **Day** for the Medici tombs, and since that time the nude figure had borne all manner of natural symbolisms until any adolescent girl could represent Spring and a fuller figure become Summer — the excuses for nakedness were manifold! But Laurens was going beyond representation of a figure, and beyond the use of figure as symbol or metaphor. Instead the human body is subjected to a metamorphosis so that it might somehow embody its own experience of itself in nature. In **Eventide** (cat. 21) the figure is barely legible in its liquid, wave-like form. Its substance pulses and flows as time passes.

Musicienne à la harpe (cat. 26) and **L'Amphion** (cat. 24) merge figure and musical instrument into one being and in **Le Ruban** (cat. 25) only the suggestion of breasts betrays any human presence. Perhaps **L'Amphion** was prompted by Paul Valery's revival of the myth in a melodrama set to music by Honegger which was first performed in Paris in 1931. The sound of Amphion's voice and lyre brought together stones to make a city and Amphion came to symbolise the union of music and architecture.

During 1937, the year in which these sculptures were made, Laurens saw the sea, remarkably, for the first time and in the following year created the first of his sirens. The sea had been a pre-occupation for some years. Its rhythms of ebb and flow, of movement without finite form embodied the continuity of time and existence.

The unceasing fertility of Picasso's formal invention was undoubtedly important to Laurens but he found a more kindred spirit in Braque. As a painter Braque's problems were different but his search had much in common with that of Laurens:

"Objects don't exist for me except in so far as a rapport exists between them and myself. When one attains this harmony, one reaches a sort of intellectual non-existence — what I can only describe as a state of peace — which makes everything possible and right. Life then becomes a perpetual revelation. That is true poetry.

Braque's still-lifes almost deny physical presence — objects appear phantom-like. But in later paintings this rapport found concrete expression in the form of a flying bird, a motif at one and the same time of solid matter and of the air.

Braque Oiseau traversant le nuage 1957 colour lithograph

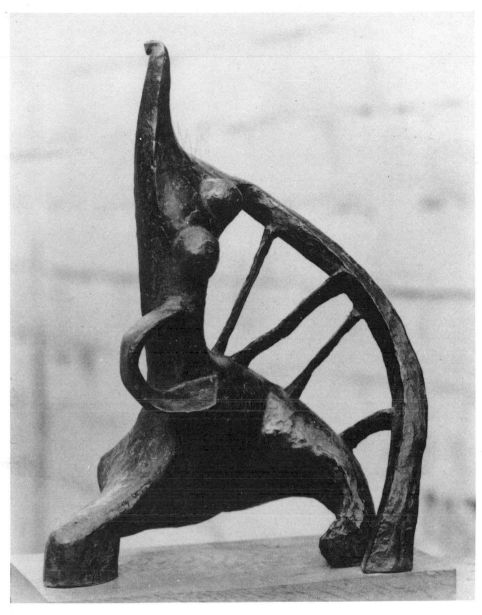

26 Musicienne à la harpe 1937

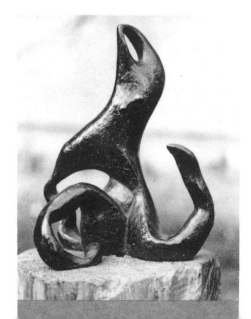

25 Le ruban 1937

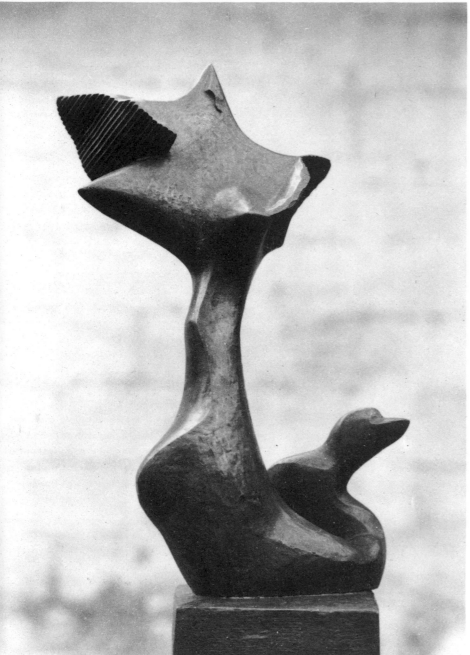

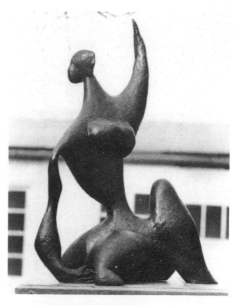

30 Le drapeau *1939*

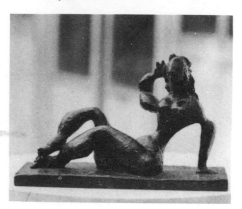

35 L'épinette *1940*

29 Sirène ailée *1938*

The siren provided Laurens with just such an emblematic figure and he made a number of sirens including an important large bronze of 1945. But from the late thirties Laurens moved back almost exclusively to the female form itself. Music is present in **La femme au banjo** (cat. 32) and **L'epinette** (cat. 35), the sea in **La corbeille** (cat. 31) and **La crieuse de poissons** (cat. 34), the wind in **Le drapeau** (cat. 30), but, instead of any crossing of breed, Laurens is depending for expression on modelled form and space and our direct relationship with another human figure. Rounded masses are linked by the narrowest ribbons. That contrast of the tense upper part of the reclining figure and its relaxed lower half is there again in **La femme au banjo.** Her slender torso descends to a bulbous belly. The bend of the legs seems to come about from clay being stretched and dropping under its own weight. Yet its curves are more of heavy liquid than clay.

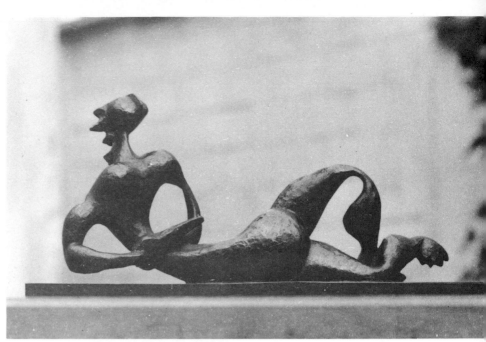

32 La femme au banjo *1939*

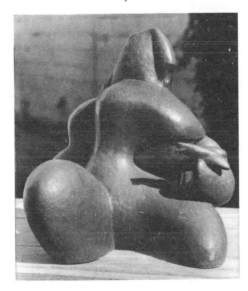

34 La crieuse de poissons *1939*

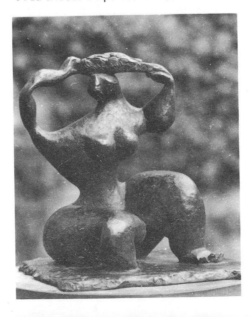

31 La corbeille *1939*

"I believe that we emanate inevitably from everything around us. Everything we do is the result of it, even if it's not a matter of exact reproduction."

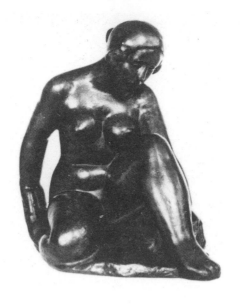

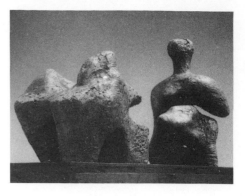

Moore Reclining figure no. 4 (Two Piece) *1962*

Maillol Study for the monument to Claude Debussy *1930*

36 L'adieu *1941*

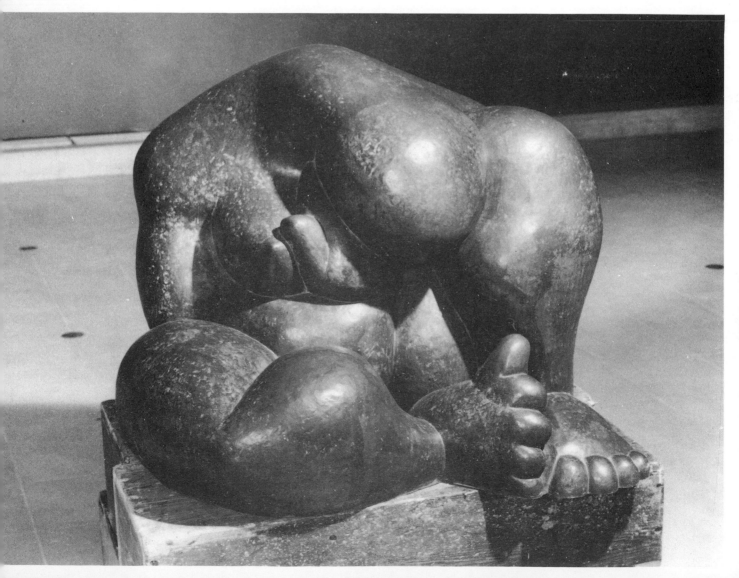

We saw earlier how Henry Moore's admiration of African and Romanesque art paralleled Laurens's likings. Both Moore and Laurens link the human form with nature yet their treatment of the female figure can be very different. Moore's figures seem to emerge from the earth itself, formed by the straining physical energies within. Bones and pebbles provide sources for the analogies he draws. Laurens worked neither from the model nor other natural forms but his aspiration to "ripeness of form" suggests comparison with fruit and it is a useful comparison to make. For the flesh of a fruit is the fulfillment of a life's cycle while it secretes and nurtures the seeds of the next generation. The outer surface is the eventually dispensable shell for its inner life.

L'adieu (cat. 36) was made in 1941, after the fall of France. The limbs which had swollen to full ripeness in space now wrapped themselves around the body to await the passing of winter, whether climatic or political. Laurens had returned to making a sculpture as a compact, self-enclosed form but now one which has been open and will re-open. As we look at the sculpture we sense not only the farewell but, optimistically, the dormant life within which will one day burst forth.

L'adieu was later to mark Laurens's own grave in the cemetery at Montparnasse but its character is far removed from the sculpture which his near neighbour, Maillol, made as a monument to Debussy. Ripe in body and self-reflecting as the Maillol figure is, we are moved by its pose and facial expression — we can sympathise. But **L'adieu** is not a separate being whom we observe. We are absorbed into its child-like sleep and dreams, allowed to dwell within the sculpture and expand to its outer form. It becomes our experience instead of an evocation of another's.

Despite its rounded mass, **L'adieu** is therefore, in a sense, Cubist sculpture brought to expressive fruition and the gap or barrier between the object observed and the eye and mind, and whole being, of the observer is dissolved.

"I aspire to ripeness of form. I should like to succeed in making it so full so juicy, that nothing could be added."

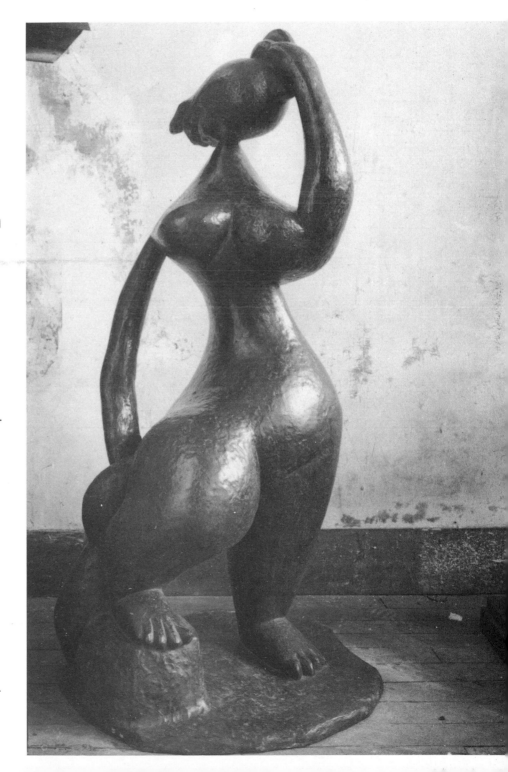

39 *La grande baigneuse 1947*

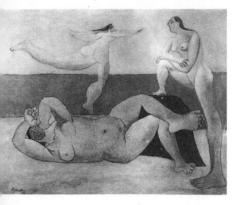

"A work of art must project its own light
and not borrow it. It is the expression of
the human quality of the artist."
Laurens quoted by L.-G. Clayeux in
Le Monde francais, February 1946

*Picasso The bathers 1923,
Chrysler Collection, New York*

0 L'automne 1948

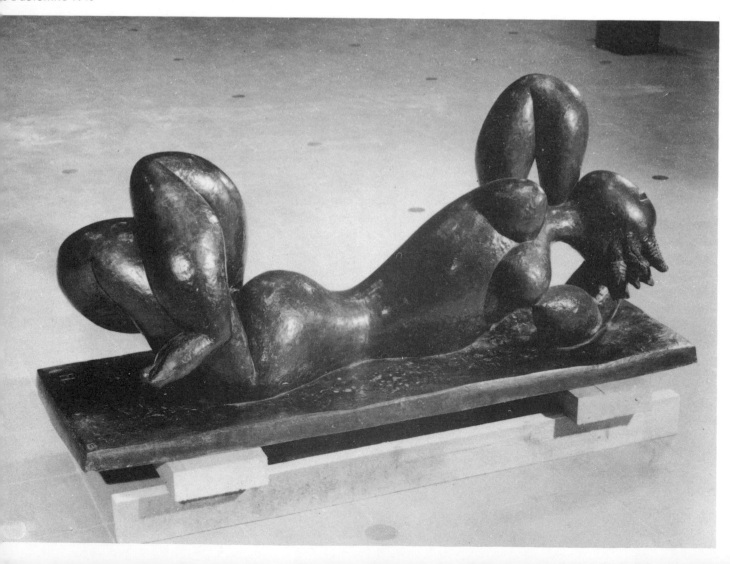

With the war over, the figure awoke and unfolded. In **La grande baigneuse** (cat. 39) Laurens can now resolve the standing figure on his own terms, and surely **L'automne** (cat. 40), with both ends of the figure twisting luxuriantly into extraordinary symmetry, is the consommation of that long progression of reclining figures which had begun in the Cubist era. Laurens's career had reached that pitch of ripeness which he was seeking in each sculpture. In these last years there are sometimes new versions of earlier works — **La petite espagnole** (cat. 43) is one of these — but **Les deux soeurs** (cat. 42) is a new departure. Recalling the early influence of African sculpture, their firm aubergine-like bodies and quizzical looks cast them as the youthful offspring of the sculptures which had gone before.

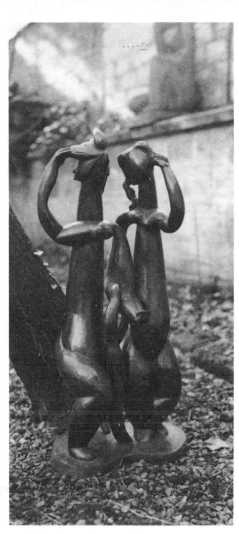

42 Les deux soeurs *1951*

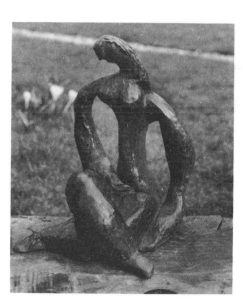

43 La petite espagnole *1954*

"What does one want? What one wants is almost indefinable. One doesn't really know what one wants. It's something felt rather than known. That's where the mystery is.
What one has inside oneself and doesn't know about is designated by a word: the unconscious. The unconscious is what has to be brought to light, is the great mystery of art."

Footnotes

1 This and following quotations by Laurens are taken from a statement made in 1951, translated by David Sylvester and published in the catalogue to the Hayward Gallery exhibition of 1971.

2 Henry Moore realised the importance of the Romanesque: "*And on further familiarity with the British Museum's whole collection it eventually became clear to me that the realistic ideal of physical beauty in art which sprang from fifth century Greece was only a digression from the main world tradition of sculpture, whilst, for instance, our own equally European Romanesque and Early Gothic are in the main line.*"
Henry Moore: *Primitive Art*, published in The Listener, April 1941, and reprinted in *Modern Artists on Art*, edited by Robert L. Herbert, published by Prentice-Hall, Inc., 1964.

3 Henry Moore noted this quality in the African's use of wood: "*. . . the Negro sculptor was able to free arms from the body, to have a space between the legs, and to give his figures long necks when he wished. This completer realisation of the component parts of the figure gives to Negro carving a more three-dimensional quality than many primitive periods where stone is the main material used.*"

Further reading

Henri Laurens by Werner Hofmann with a recollection by the art dealer D-H Kahnweiler, published by Harry N. Abrams Inc., New York, 1970.

Le Point (Souillac, July 1946, no. 33) — a special number of this periodical devoted to Laurens including contributions by M. Raynal, P. Reverdy, G. Limbour, M. Leiris, P. Leibowitz and B. Lobo.

The catalogues to the Grand Palais exhibition in Paris of 1967 and the Hayward Gallery exhibition of 1971, the latter including translations of a statement by Laurens himself and an appreciation by Giacometti.

The later drawings

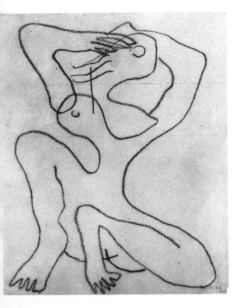

63 Femme assise aux bras levés *c1946*

68 Femme fleur *c1948*

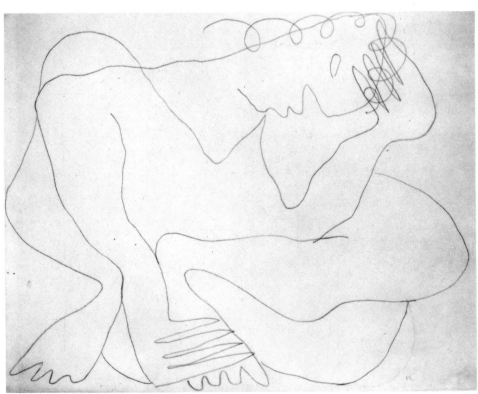

55 Femme accroupie *1935-40*

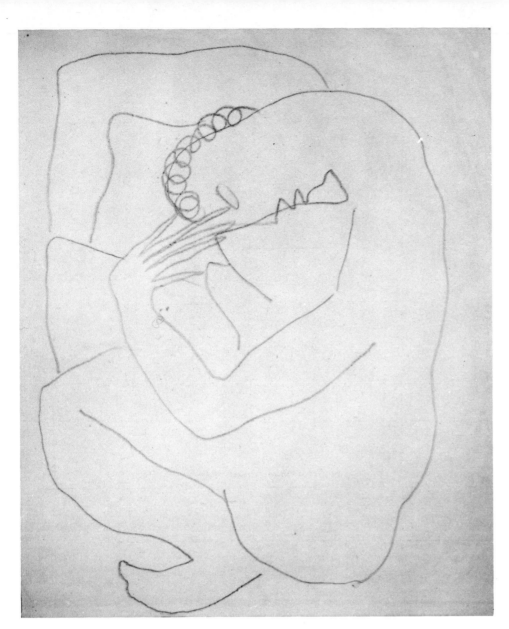

70 Femme assise 1949

84 Femme assise à la jambe levée 1950

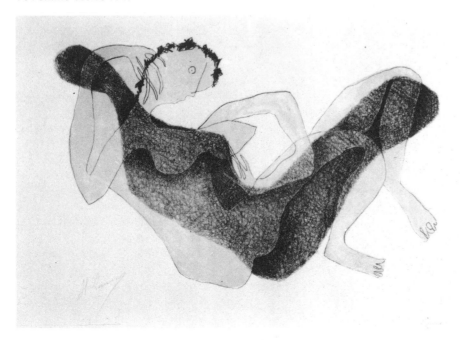

85 Femme allongée au bras levé 1950

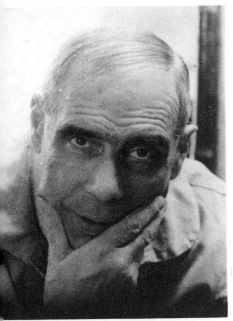

"As much as it can be said of any human being, he was happy."
Marthe Laurens: *Henri Laurens, sculpteur*, volume I, 1955

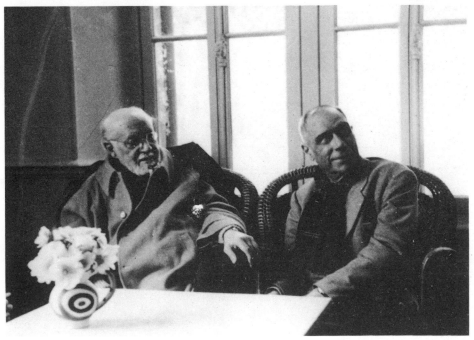

top right
Laurens with Braque
Laurens with Matisse

Daniel-Henry Kahnweiler, the gallery owner and friend of the Cubists, recalled Laurens as a man of few but thoughtful words with a discreet sense of humour.

They met when Laurens was living in Montmartre. Picasso had then left for Montparnasse but Juan Gris was still at the Bateau Lavoir and Braque and Laurens were near enough to wave to each other from their windows. The house was small and poor yet kept clean and well-ordered by Laurens's wife, Marthe.

Laurens later became a neighbour of Maillol and Ker-Xavier Roussel, not far from Marly-le-Roi outside Paris. Finally he took a house in the south of Paris where he was again to be close to Braque. The house was small but a good-sized studio

allowed work on large sculptures and, behind the house, he could set out works in the garden.

Laurens had contracted osteo-tuberculosis in 1902 and one leg was amputated. Pain and illness recurred throughout his life and he rarely travelled far from his native Paris. But his son, Claude, remembers their home as a meeting place for poets, painters and musicians who would come to relax in its calm, to talk and enjoy Madame Laurens's cooking: poetry and music were of the utmost importance to him. And despite illness his work was regular — illness was one thing, life another — the main body of his later drawings dating from those times when he was unable to work on sculpture.

catalogue

Unless otherwise stated, the works are borrowed from private collections in Paris. Measurements are given in centimetres, height before width. Sculptures are bronze and drawings pencil except where another medium is indicated.

Catalogue numbers 45, 46 and 52 will not be shown in Hull.

sculptures

1 Femme à l'éventail 1919
Woman with fan
27.5×61
Galerie Louise Leiris

2 Femme à l'éventail 1921
Woman with fan
51×39, relief
Galerie Louise Leiris

3 Femme couchée 1922
Woman lying
56×160, bas-relief
Galerie Louise Leiris

4 Compotier et grappes de raisins 1922
Fruit dish with bunches of grapes
46×60, bas-relief
Galerie Louise Leiris

5 Femme couchée au miroir 1922
Woman lying with mirror
10×24

6 Tête de femme 1925
Head of woman
42×20

7 Guitare 1926
Guitar
152×91, bas-relief
Galerie Louise Leiris

8 Femme couchée à la draperie 1927
Woman lying with drapery
28×84
Galerie Louise Leiris

9 Femme debout à la draperie au bras levé 1928
Woman standing with drapery and raised arm
38×13
Galerie Louise Leiris

10 Femme debout à la draperie 1928
Woman standing with drapery
53.5×22
Galerie Louise Leiris

11 Femme à la draperie 1928
Woman with drapery
71×31

12 Grande femme au miroir 1929
Woman with mirror (large version)
71.5×30.5
Galerie Louise Leiris

13 Cariatide 1930
Cariatid
91×45×57
Galerie Louise Leiris

14 Baigneuse (fragment) 1931
Bather
57×69
Galerie Louise Leiris

15 Femme à l'oiseau 1932
Woman with bird
39.5×30
Galerie Louise Leiris

16 Architecture 1932
Architecture
21×25
Galerie Louise Leiris

17 Femme accroupie à la draperie 1932
Crouching woman with drapery
35×27

18 La vague 1932
The wave
40.5×42

19 Petites Ondines 1933
Undines (small version)
19×42

20 La négresse 1934
The negress
74×43
Galerie Louise Leiris

21 Eventide 1935
11×36
Galerie Louise Leiris

22 Rosa 1935
26×25.5
Galerie Louise Leiris

23 Le torse 1935
The torso
65.5×49
Ida Chagall, Paris

24 L'Amphion (petit) 1937
Amphion (small version)
55×16

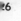

38 La chevelure *1946*

25 Le ruban 1937
 The ribbon
 23.5×19.5

26 Musicienne à la harpe 1937
 Musician with harp
 40.5×30

27 Sirène au bras levé 1938
 Siren with raised arm
 16.5×35.5
 Galerie Louise Leiris

28 Petite sirène ailée 1938
 Winged siren (small version)
 25×17

29 Sirène ailée 1938
 Winged siren
 59.5×27
 Galerie Louise Leiris

30 Le drapeau 1939
 The flag
 59.5×40

31 La corbeille 1939
 The basket
 30×30

32 La femme au banjo 1939
 Woman with banjo
 19.5×39.5

33 L'acrobate au tapis 1939
 Acrobat on the carpet
 31×30

34 La crieuse de poissons 1939
 The fish-crier
 28×30

35 L'épinette 1940
 The spinet
 13×20.5

36 L'adieu 1941
 The farewell (large version)
 73×85×69
 Galerie Louise Leiris

37 La dormeuse 1943
 The sleeper
 15×22

38 La chevelure 1946
 The hair
 35×20

39 La grande baigneuse 1947
 Bather (large version)
 160×70
 Galerie Louise Leiris

40 L'automne 1948
 Autumn
 76.2×193×50.8
 The Trustees of the Tate Gallery

41 La grande nuit 1950
 Night (large version)
 26×70
 Galerie Louise Leiris

42 Les deux soeurs 1951
 The two sisters
 88×43
 Galerie Louise Leiris

43 La petite espagnole 1954
 Spanish woman (small version)
 25×23
 Galerie Louise Leiris

44 Femme à la draperie 1954
 Woman with drapery
 11×34
 Galerie Louise Leiris

48 La tête *1917*

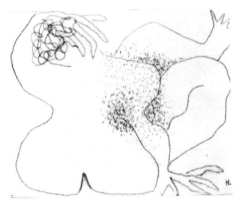

62 Femme assise de dos *1940*

collages

45 Instrument de musique 1916
Musical instrument
36×56
Private Collection, London

46 La bouteille de Beaune 1917
The bottle of Beaune
28×22
JPL Fine Arts, London

47 Bouteille et verre 1917
Bottle and glass
59×39.5

48 La tête 1917
Head
40×57
Ida Chagall, Paris

49 Femme à la mantille 1917
Woman with mantilla
59×39.5

50 Nature morte 1918
Still life
33×41.5
Ida Chagall, Paris

drawings

51 Tête de boxeur 1916
Head of boxer
15×11.2, ink

52 Tête c1919
Head
28.3×18.7, gouache & black crayon
Private Collection, London

53 Le jockey - Anselme 1920
The jockey - Anselme
23.5×15.8, ink

54 Femme assise c1935-40
Seated woman
55.7×38.6

55 Femme accroupie 1935-40
Crouching woman
45×56

56 Femme accroupie 1940
Crouching woman
44.5×56.2

57 Femme accroupie 1940
Crouching woman
45×56

58 L'ange à la trompette 1940
Angel with trumpet
56×45

59 Femme 1940
Woman
45×56

60 Femme aux fruits 1940
Woman with fruit
56×45

61 La marchande de poissons 1940
The fish-seller
56×45

62 Femme assise de dos 1940
Seated woman from the back
23.5×28.2

63 Femme assise aux bras levés c1946
Seated woman with raised arms
28.5×22.5

64 Femme agenouillée 1947
Kneeling woman
drawing engraved with a point
on a ground of sanguine on card

65 Femme couchée c1948
Lying woman
27×32.5

66 Femme fleur c1948
Woman-flower
28.5×22.5

67 Femme fleur c1948
Woman-flower
22.5×28.5

68 Femme fleur c1948
Woman-flower
22.3×28.3

69 Nu assis 1948
Seated nude
45.5×28

70 Femme assise 1949
Seated nude
56.2×45

71 Femme accoudée 1950
Woman leaning
45×56

72 Femme à la corbeille c1950?
Woman with basket
56×45

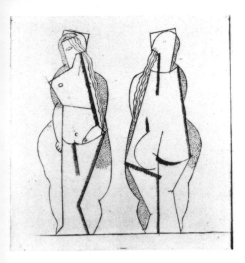

74 Nus *1921*

prints

73 Hortense 1920-21
24.8×12 etching

74 Nus 1921
Nudes
22×23.8 etching

75 La joueuse de guitare 1921
The guitar player
23.7×15.9 etching

76 Deux femmes étendues 1921
Two women lying
24×18 etching/drypoint

77 Le guéridon 1927
Table
24.8×18.9 etching

78 Valencia 1927
16.7×22 etching

79 *La dernière nuit* de Paul Eluard 1942
(study for frontispiece)
The last night by Paul Eluard
17.8×12.8 etching (artist's proof)

80 *La dernière nuit* de Paul Eluard 1942
(frontispiece)
The last night by Paul Eluard
17.8×12.8 etching (working proof)

81 Femme debout 1950
Standing woman
c36×22 lithograph

82 Femme accroupie 1950
Crouching woman
58.5×38 lithograph

83 Femme couchée 1950
Lying woman
26×49.5 lithograph

84 Femme assise à la jambe levée 1950
Seated woman with leg raised
44×23.5 lithograph

85 Femme allongée au bras levé 1950
Reclining woman with arm raised
29×46 lithograph

86 Aurélie 1946
Aurelia
15.7×21.8 etching

Graves Art Gallery, Sheffield	19 January to 17 February 1980
Dundee Museum	23 February to 15 March
National Museum of Wales, Cardiff	26 March to 27 April
Ferens Art Gallery, Hull	3 May to 8 June

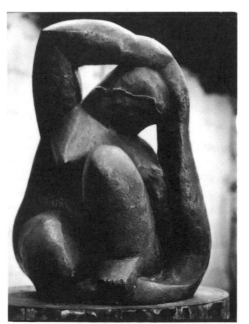

17 Femme accroupie à la draperie *1932*

designed by Trilokesh Mukherjee
printed in England by Raithby Lawrence
photographs by Michel Desjardins,
John Webb, Lydin, Ninette Lyon,
Brassai, Archive Claude Laurens

ISBN 0 7287 0225 8
©Arts Council of Great Britain 1980

A list of Arts Council publications,
including all exhibition catalogues in
print, can be obtained from
the Publications Office,
Arts Council of Great Britain,
105 Piccadilly,
London W1V 0AU.

Henri Laurens

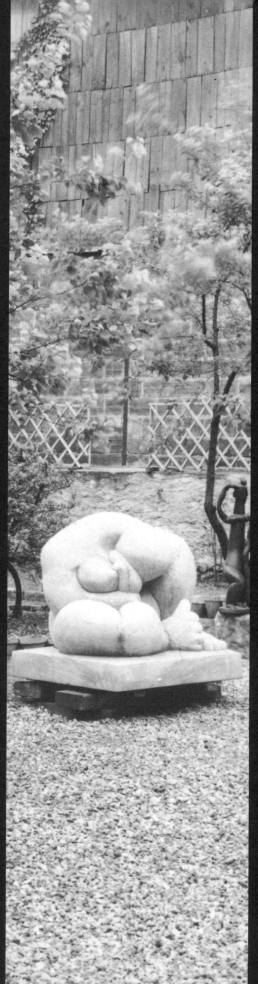

Arts Council
OF GREAT BRITAIN